T0197312

Urban Expressions

Urban Expressions

MICHAEL LANG

URBAN EXPRESSIONS

iUniverse books may be ordered through booksellers or by contacting:

iUniverse
1663 Liberty Drive
Bloomington, IN 47403
www.iuniverse.com
1-800-Authors (1-800-288-4677)

Because of the dynamic nature of the Internet, any web addresses or links contained in this book may have changed since publication and may no longer be valid. The views expressed in this work are solely those of the author and do not necessarily reflect the views of the publisher, and the publisher hereby disclaims any responsibility for them.

Any people depicted in stock imagery provided by Getty Images are models, and such images are being used for illustrative purposes only. Certain stock imagery © Getty Images.

ISBN: 978-1-5320-7099-0 (sc)
ISBN: 978-1-5320-7100-3 (e)

Library of Congress Control Number: 2019903067

Print information available on the last page.

iUniverse rev. date: 03/13/2019

From the Artist

This book was created for relaxation and
fun. The designs are taken from an assortment
of my signature Urban Expression paintings
which reflect both moods and color variation.
My hope is that it also inspires and promotes
creativity...Enjoy!

www.MLangArt.com

'Pose'

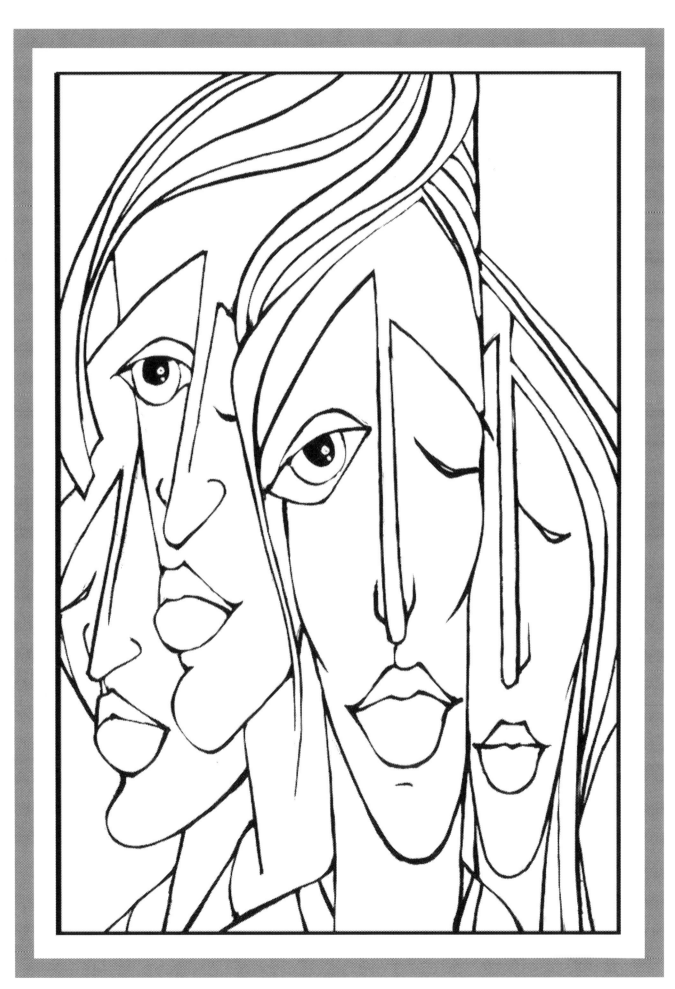

'Autumn'

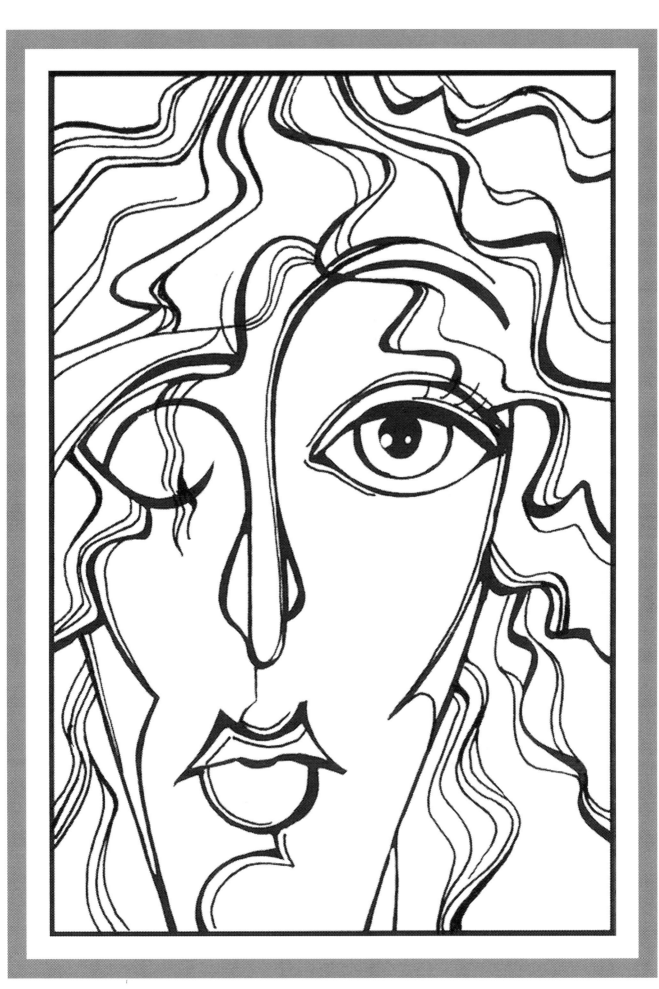

'Untitled'

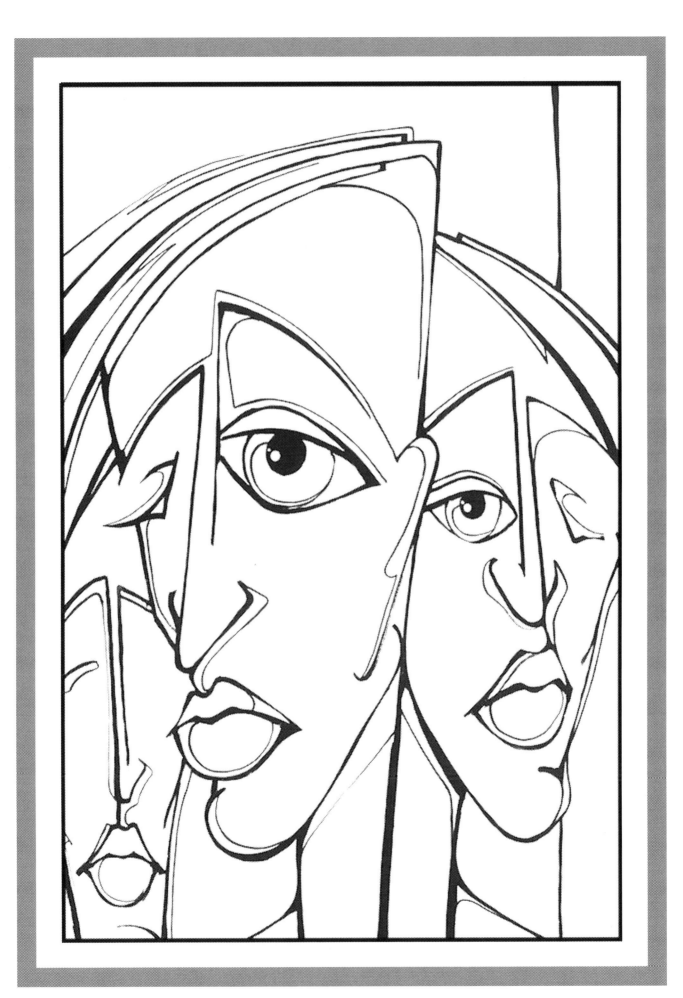

'Watch'

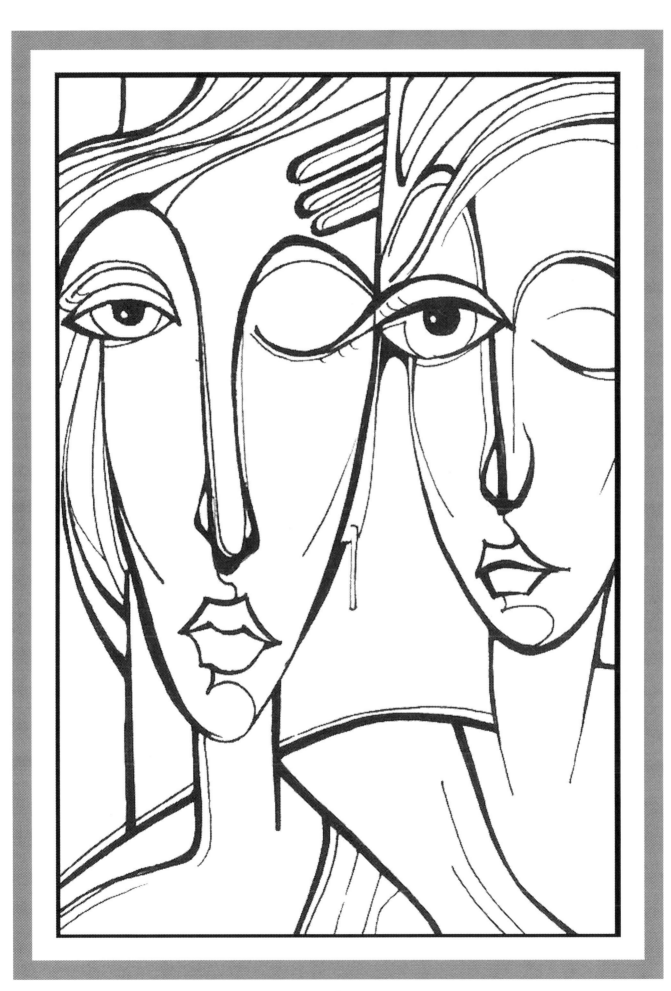

'Untitled 2'

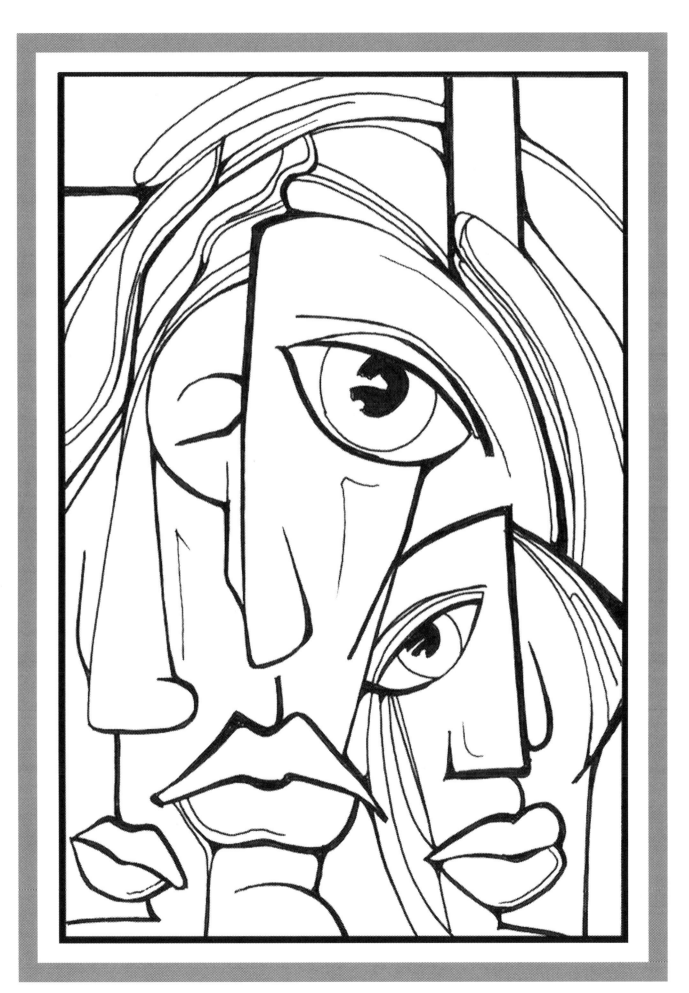

'Urban
Expression'

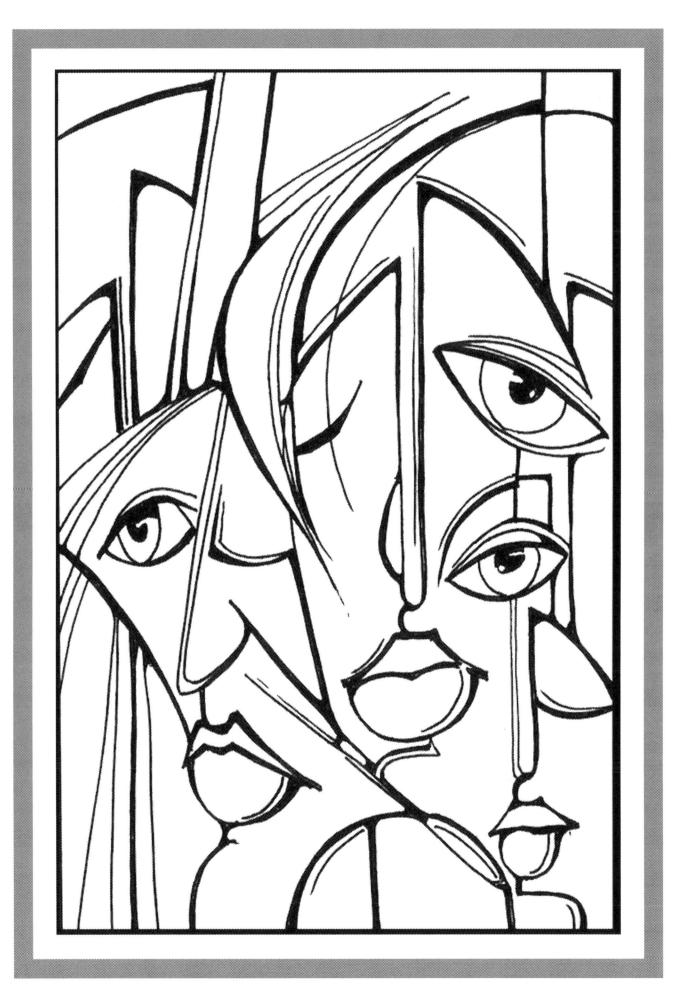

'Look'

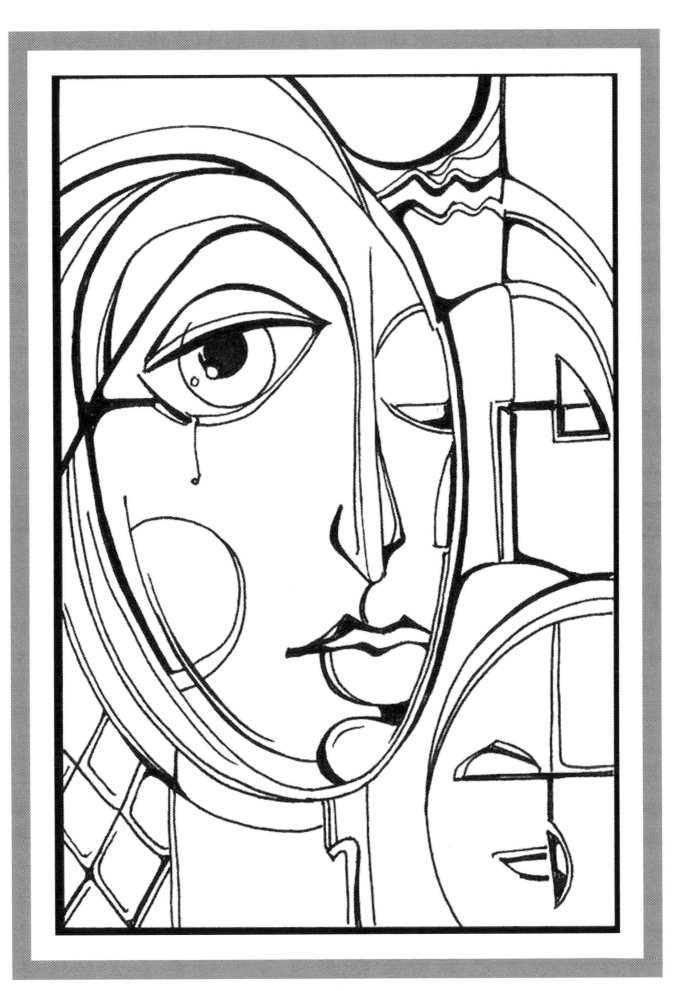

'The Dream'

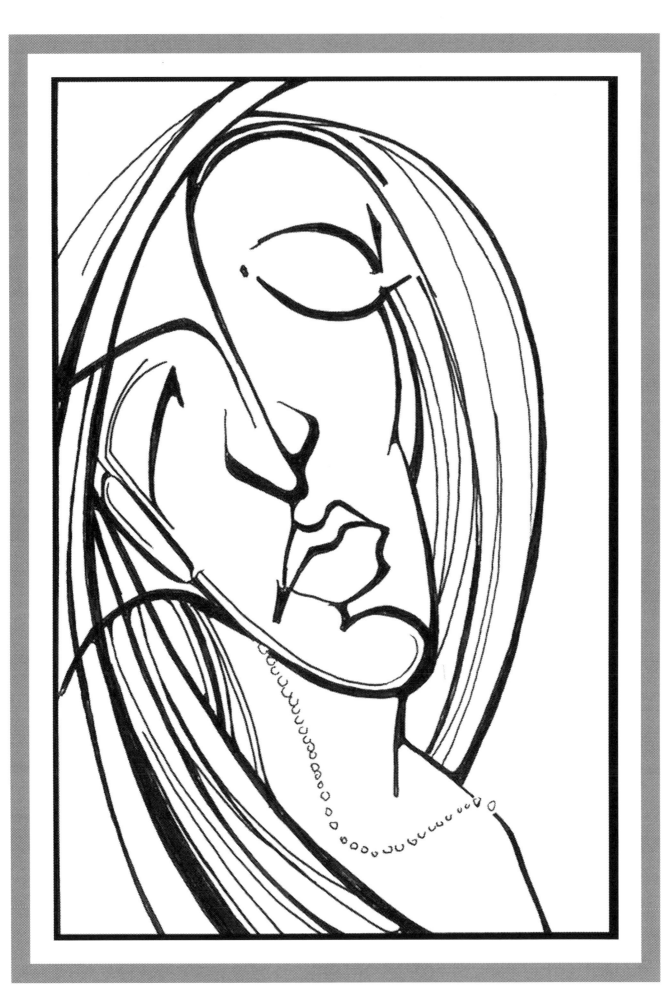

'Watching'

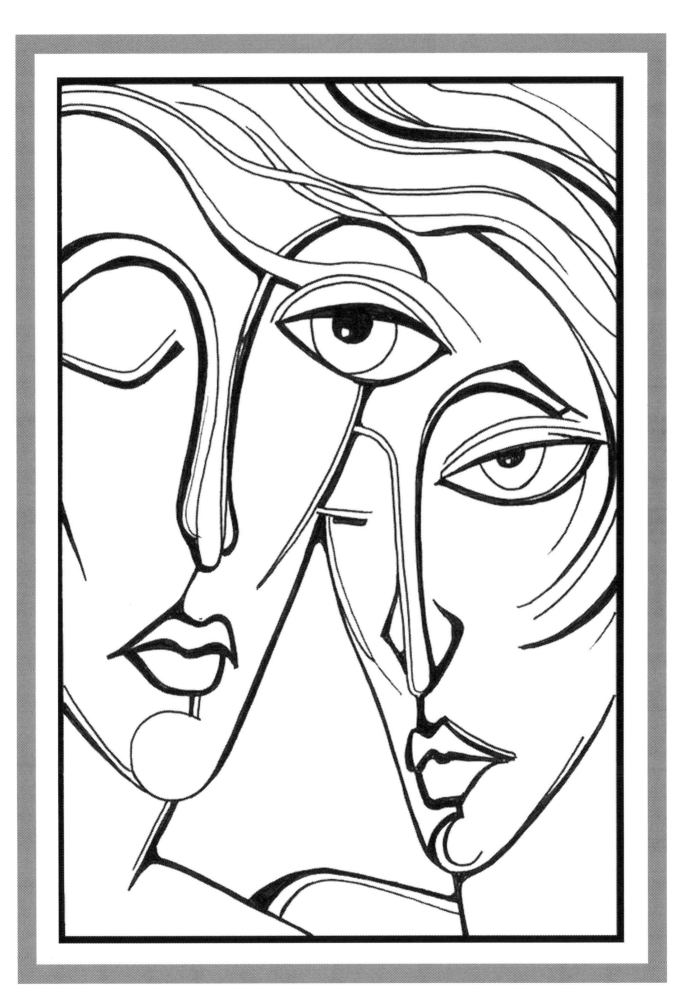

'The Union'

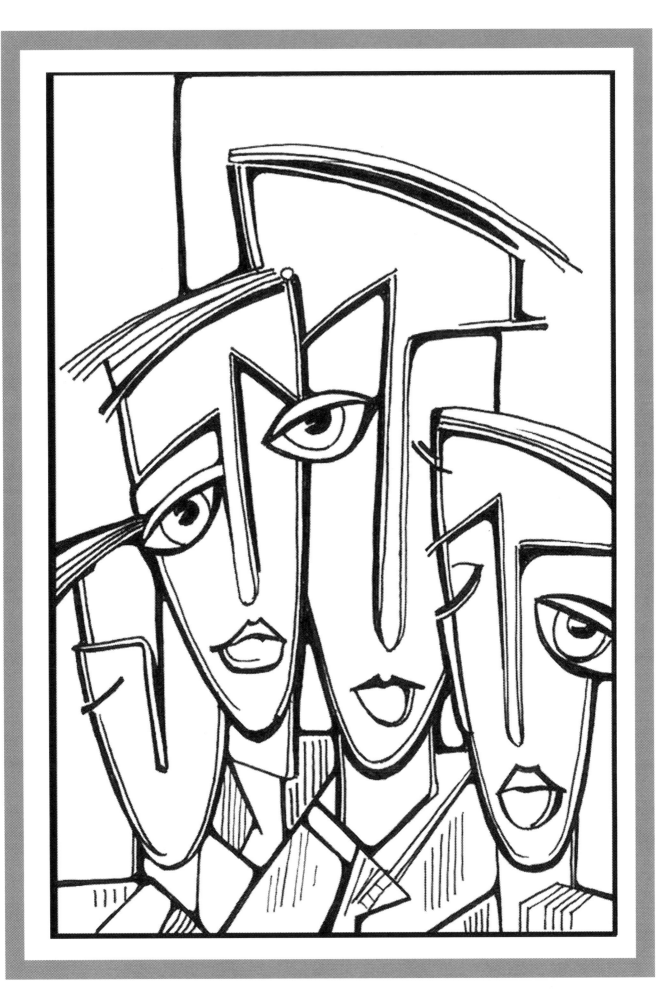

'Conference Room'

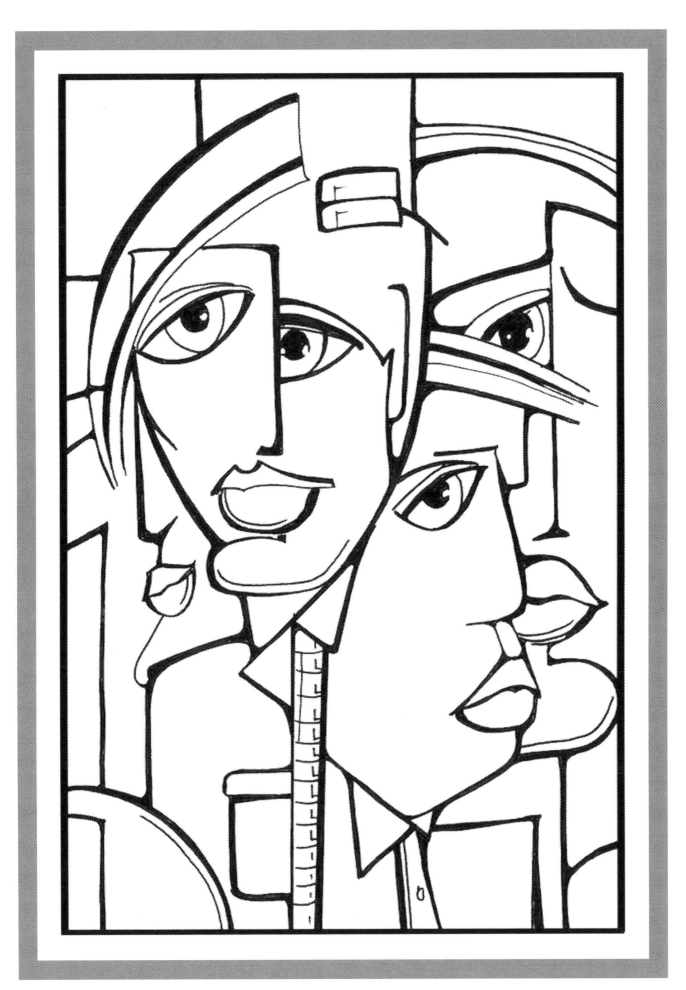

'Expressions'

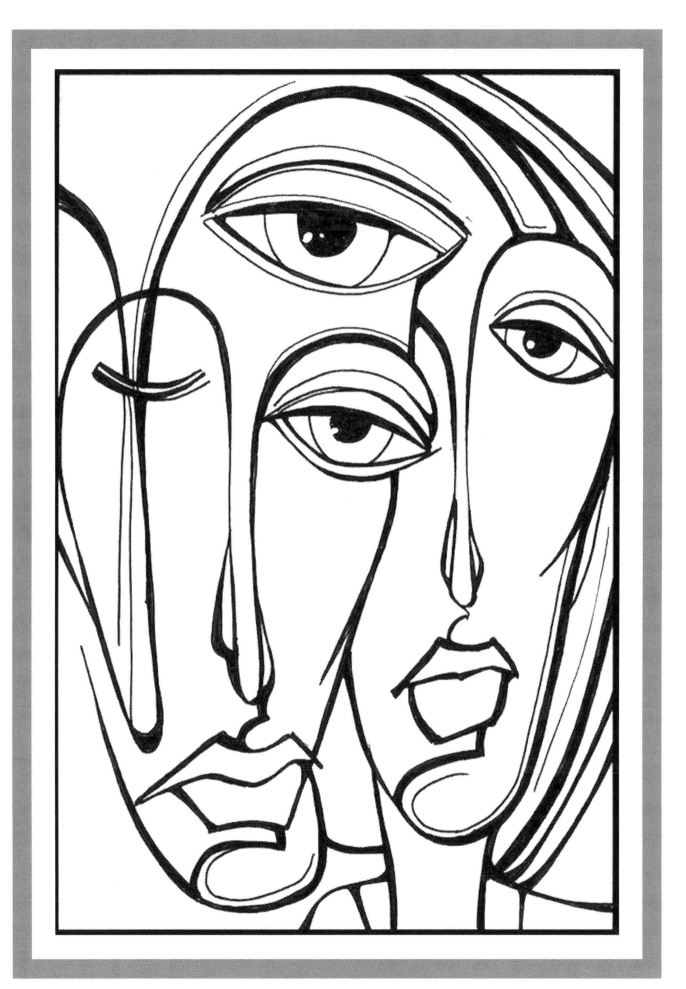

'Blue'

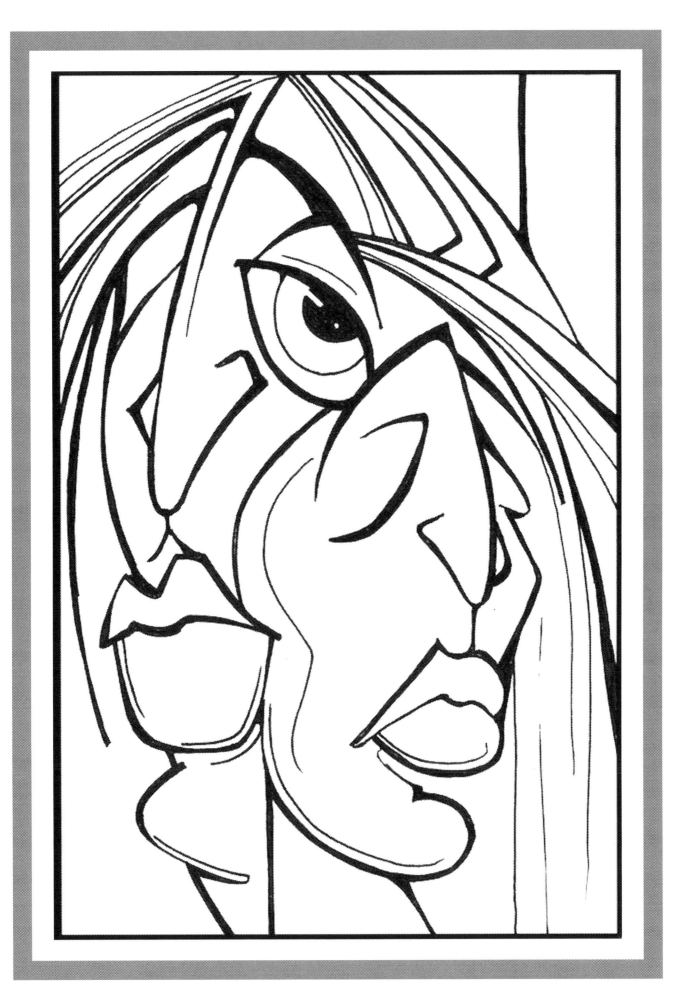

'Ditto'

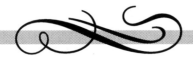

'Wanderers'

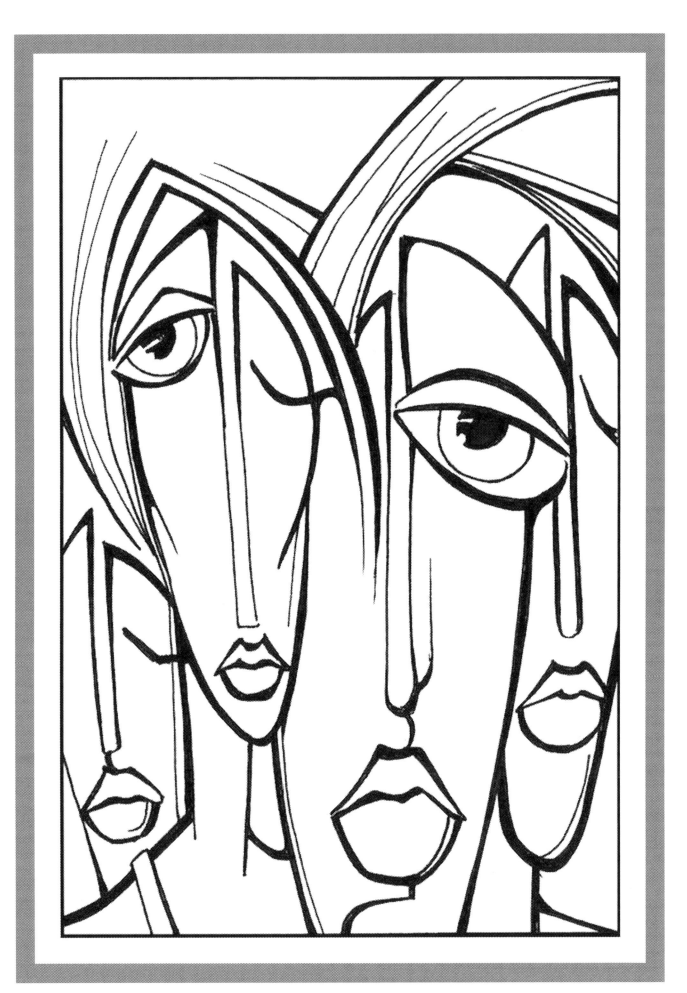

'Searching for Eve'

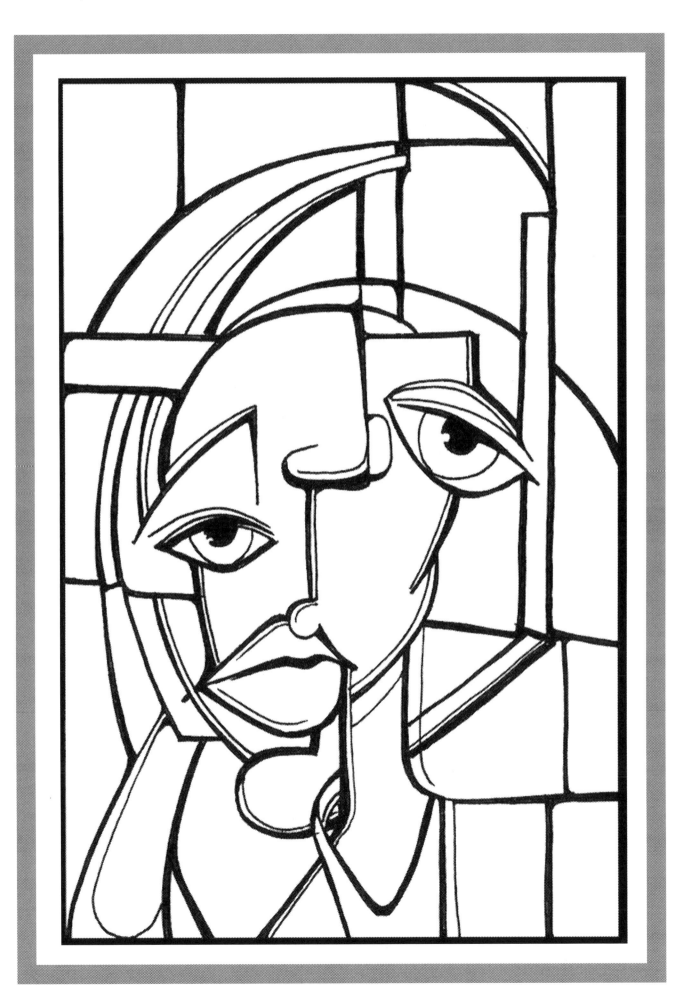

'Tangle'

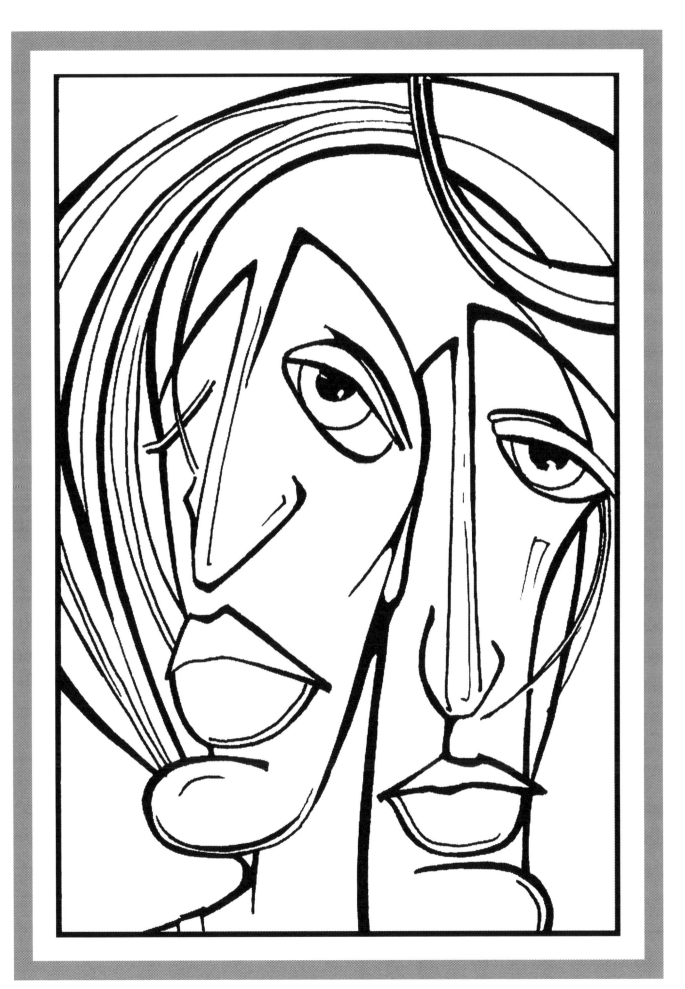

'Blend'

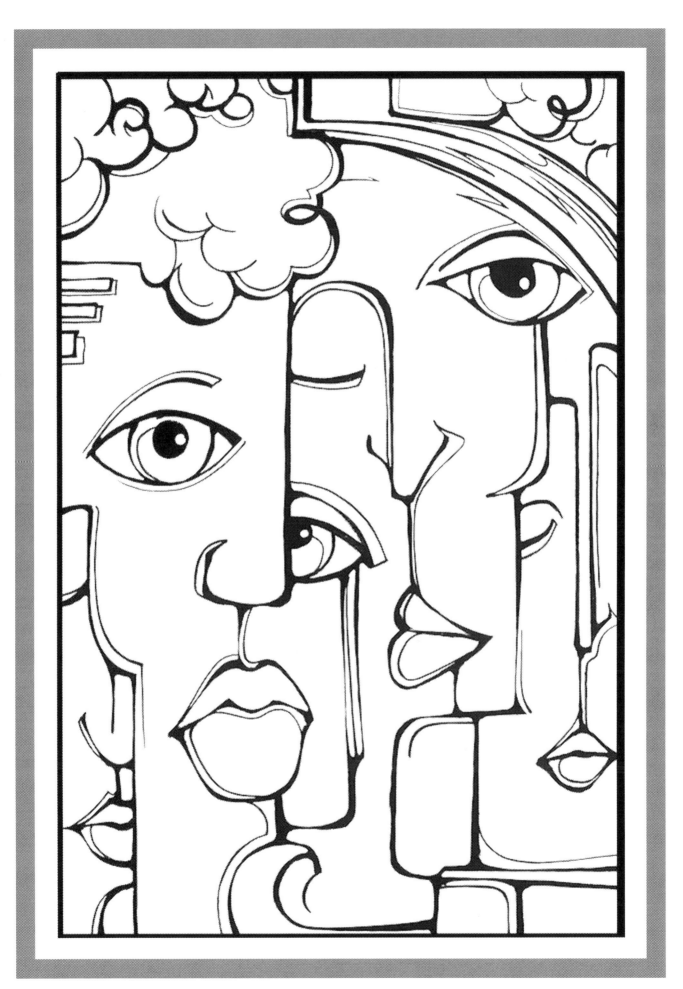

'Image'

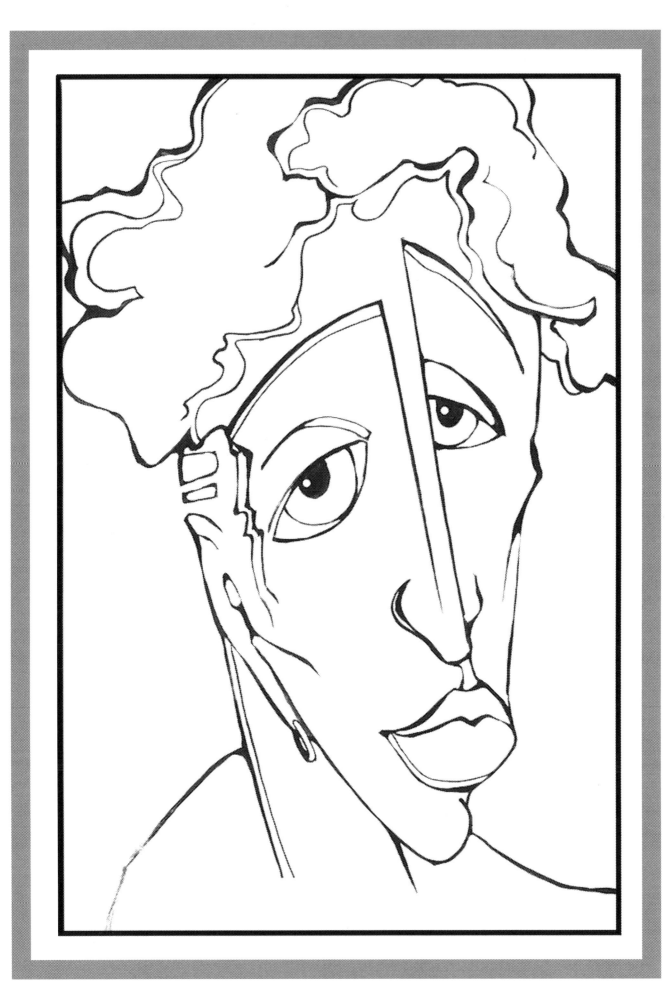

'Dreamers'

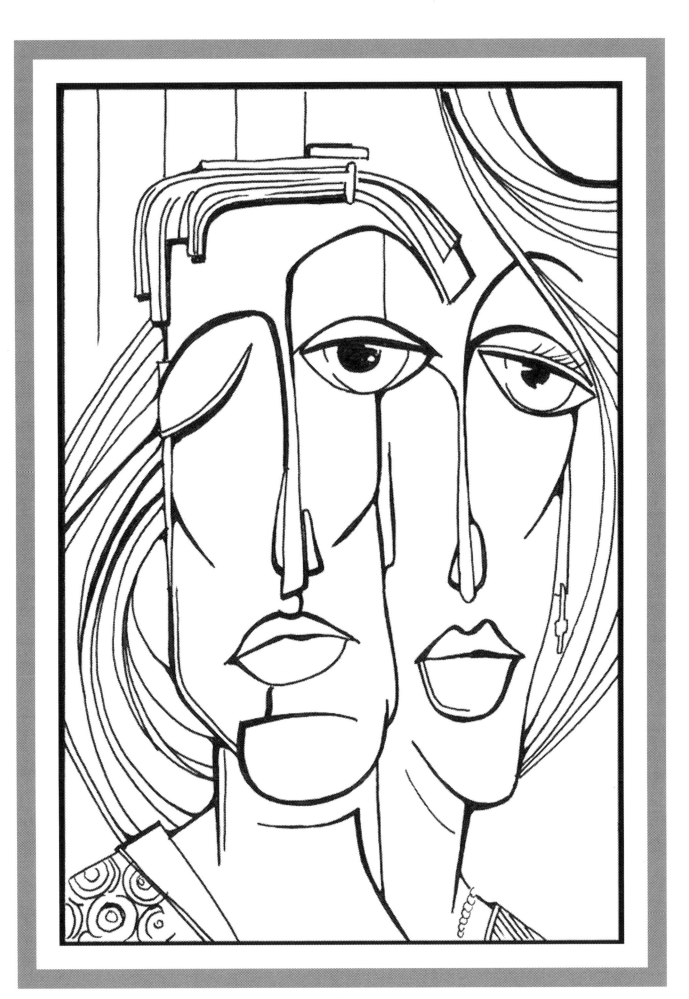

'Together'

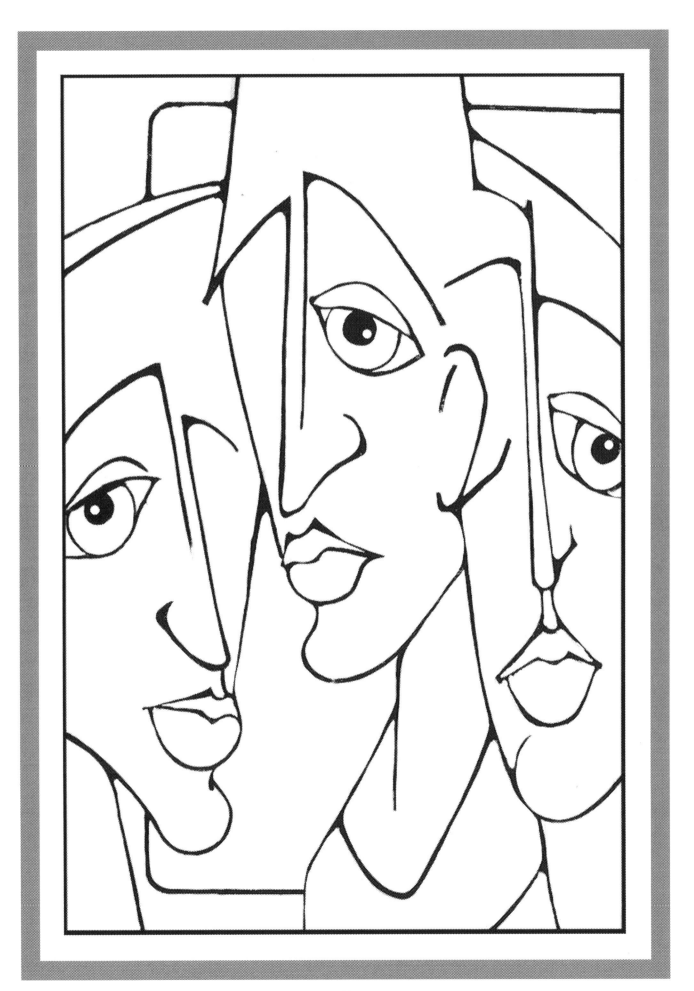

'Together 2'

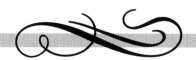

'Luna'

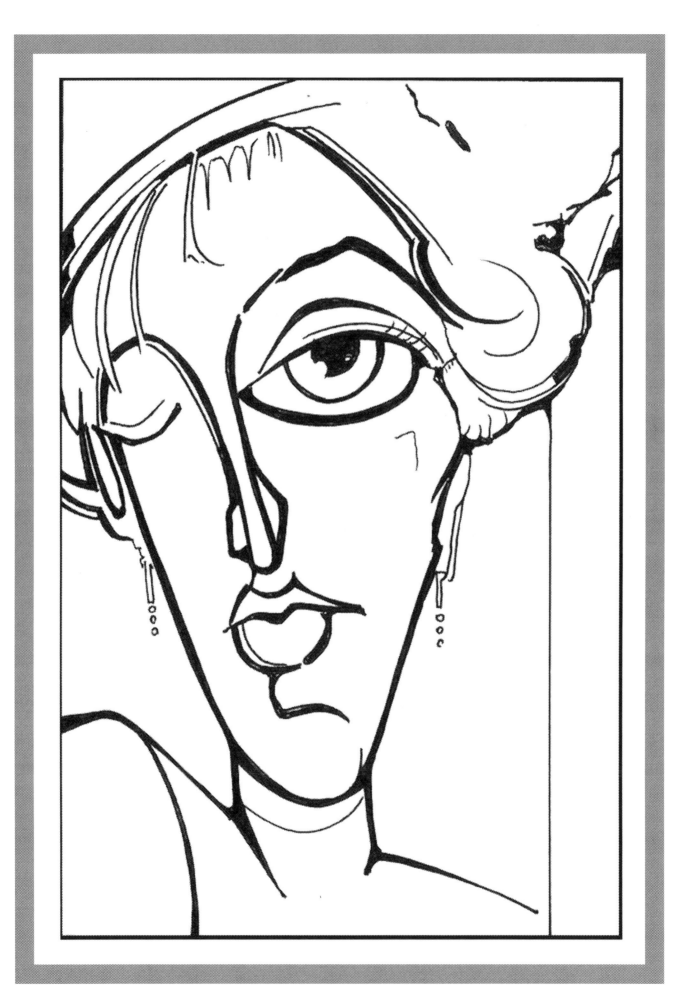

'Cut'

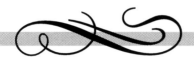

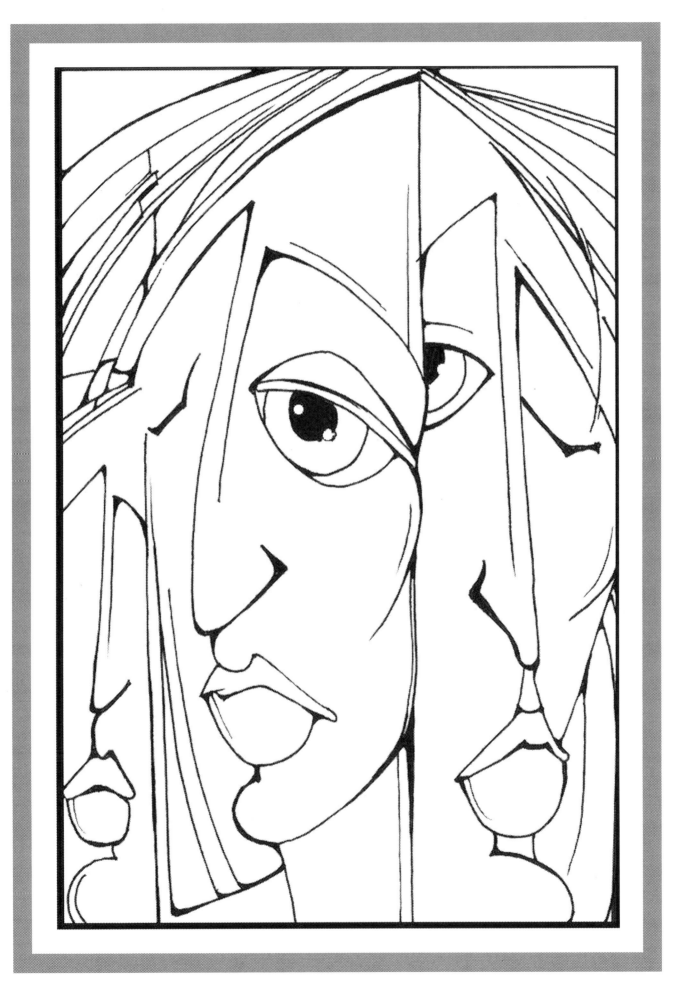

'Drift'

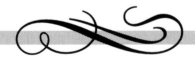

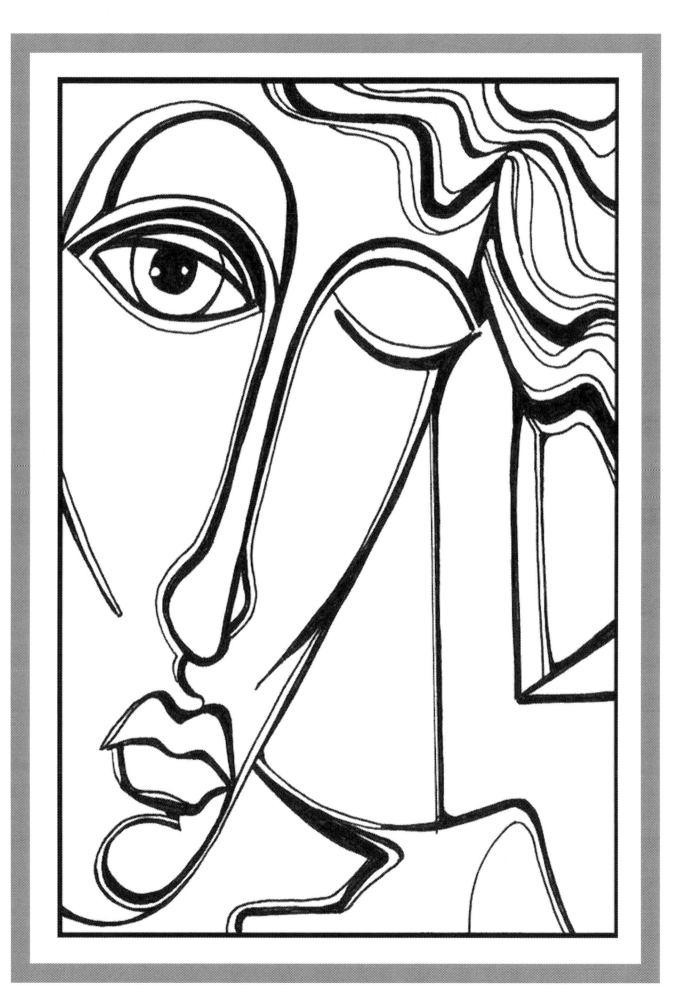

'Without a Sound'

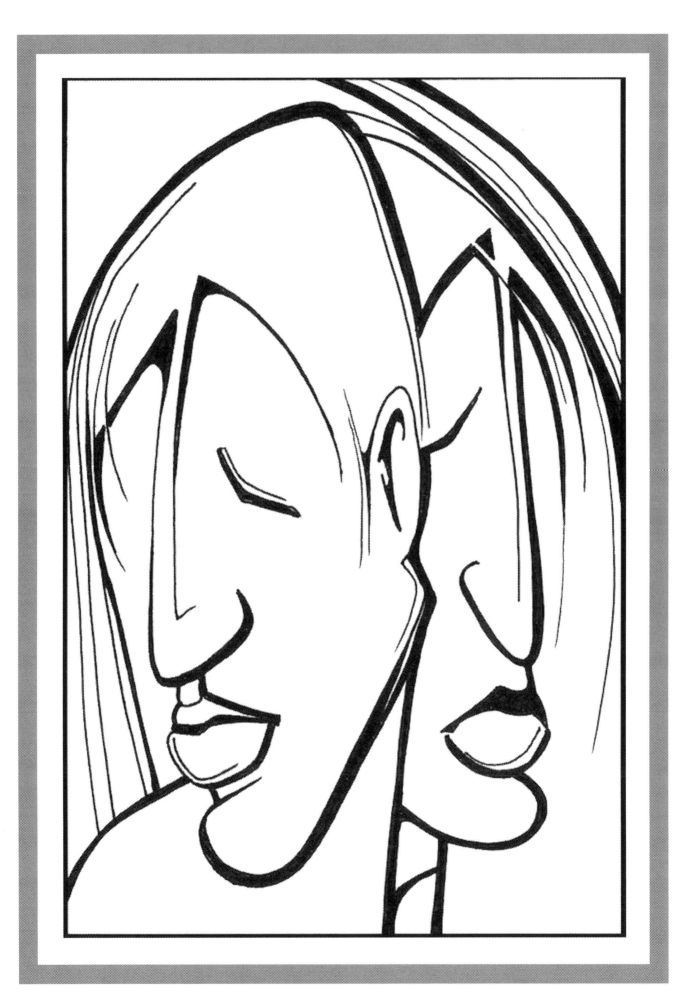

'Spotlight'

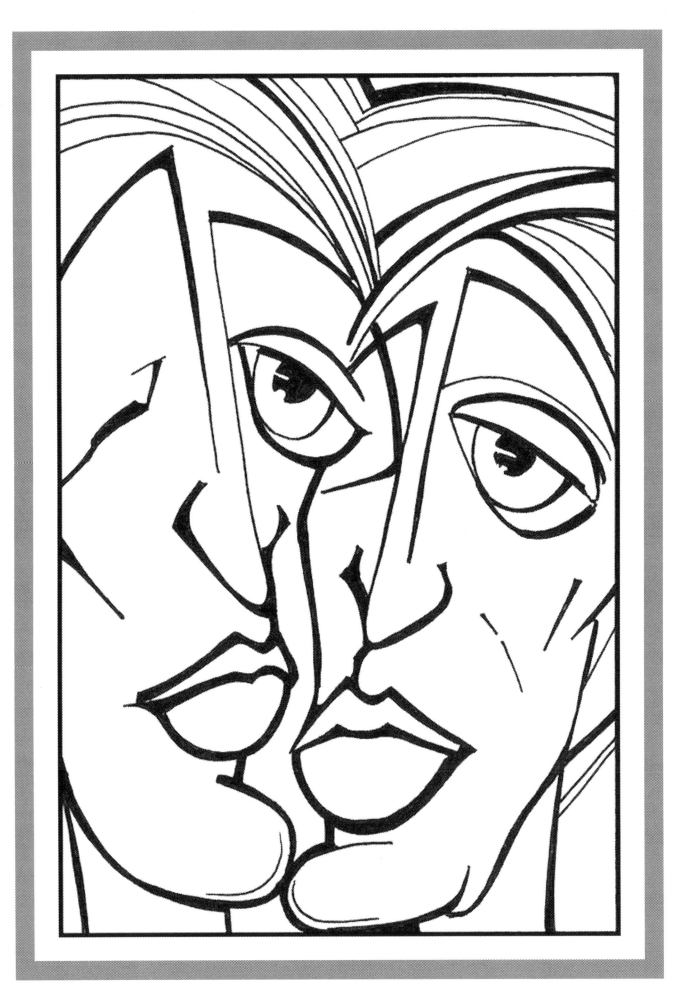

'One Voice'

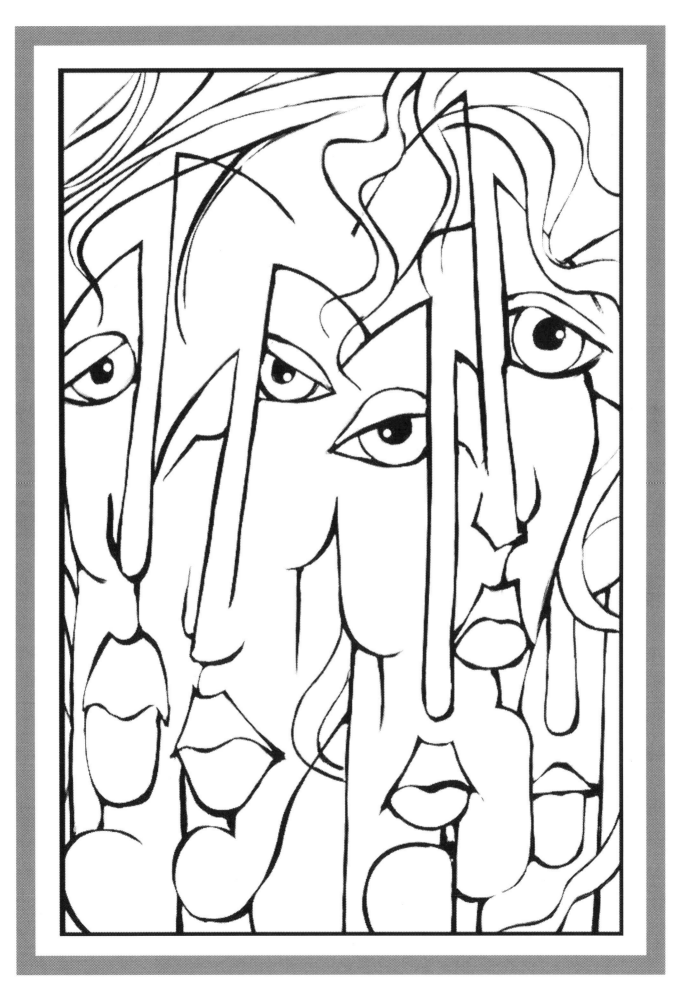

'Imagined'

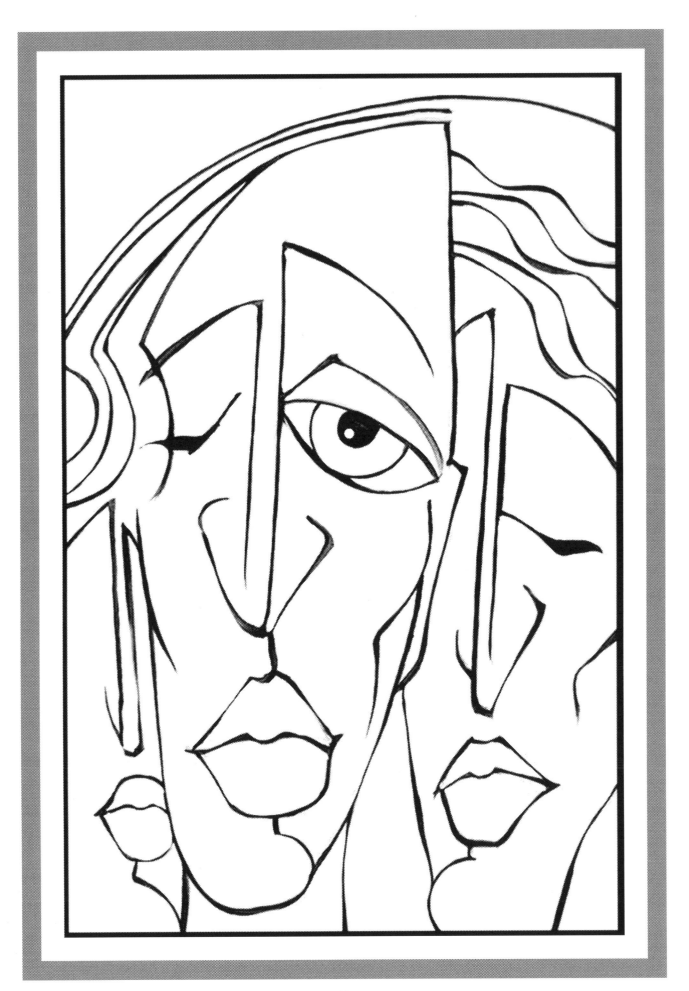

'Different Approach'

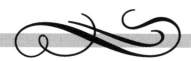

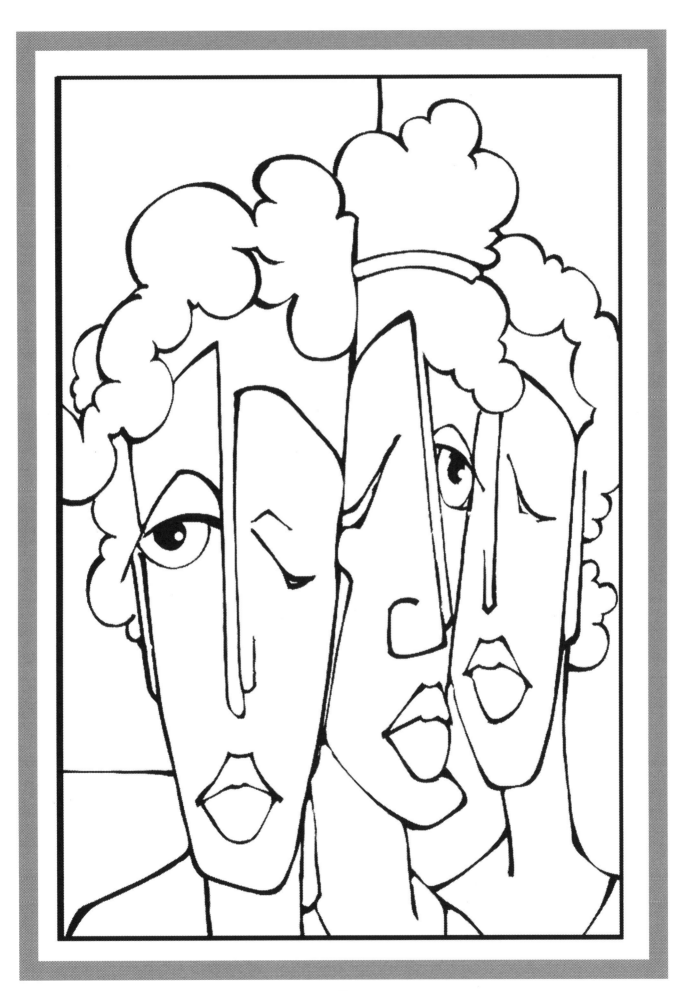

'Choosing Sides'

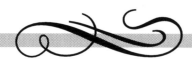

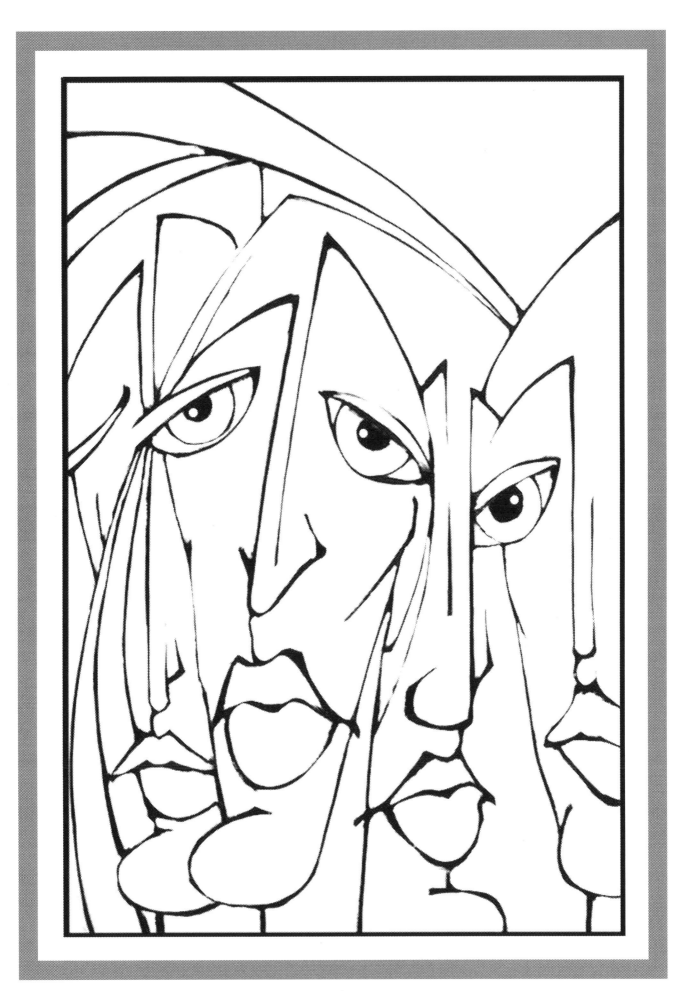

'Click'

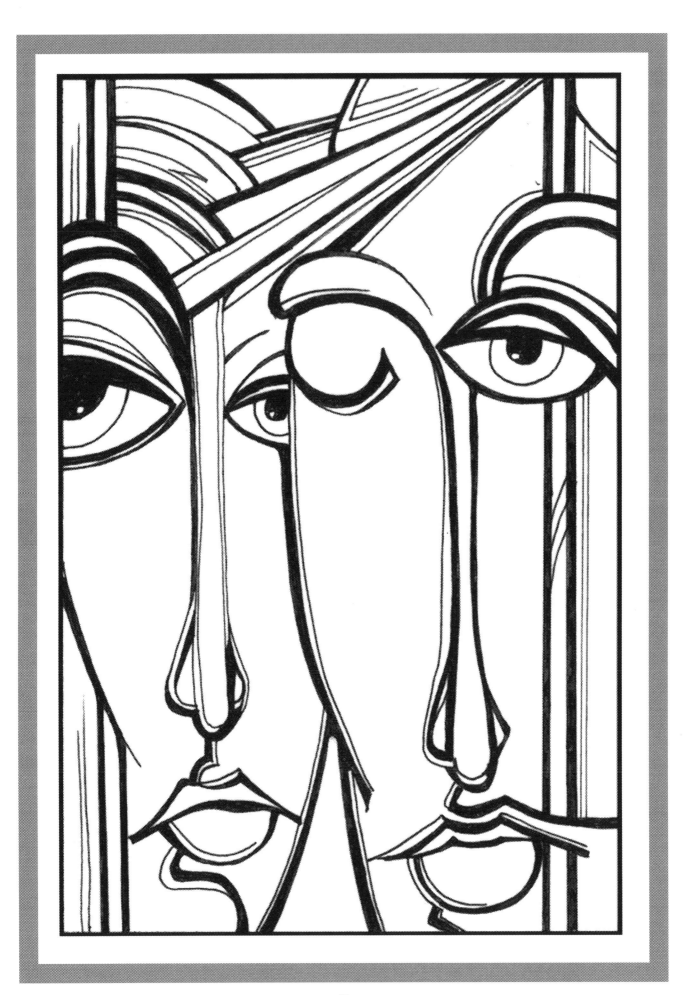

'Faces'

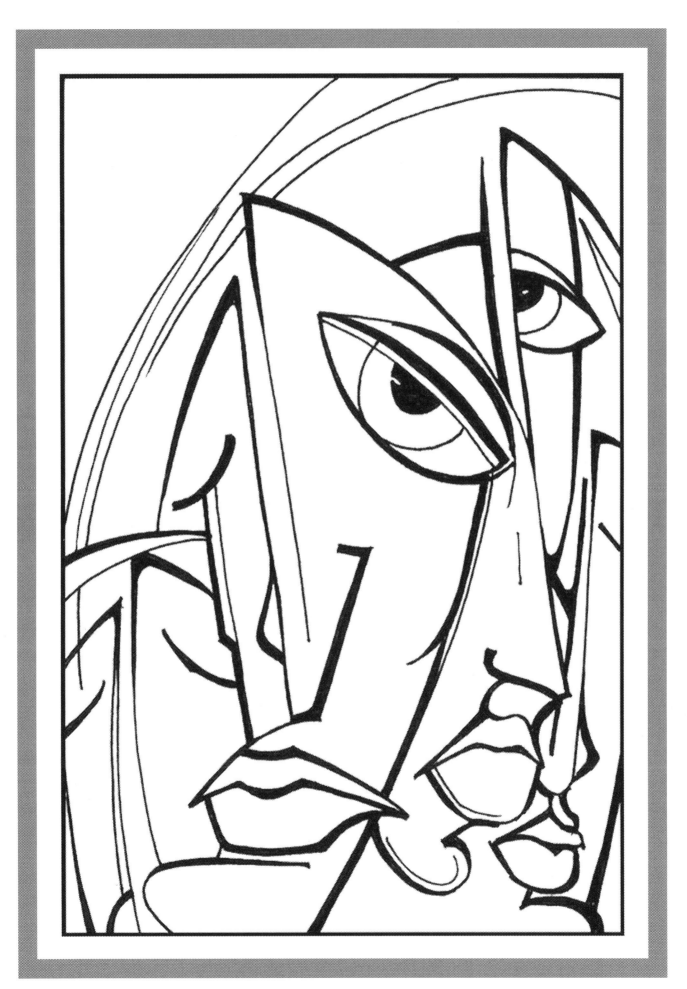

'Suspicion'

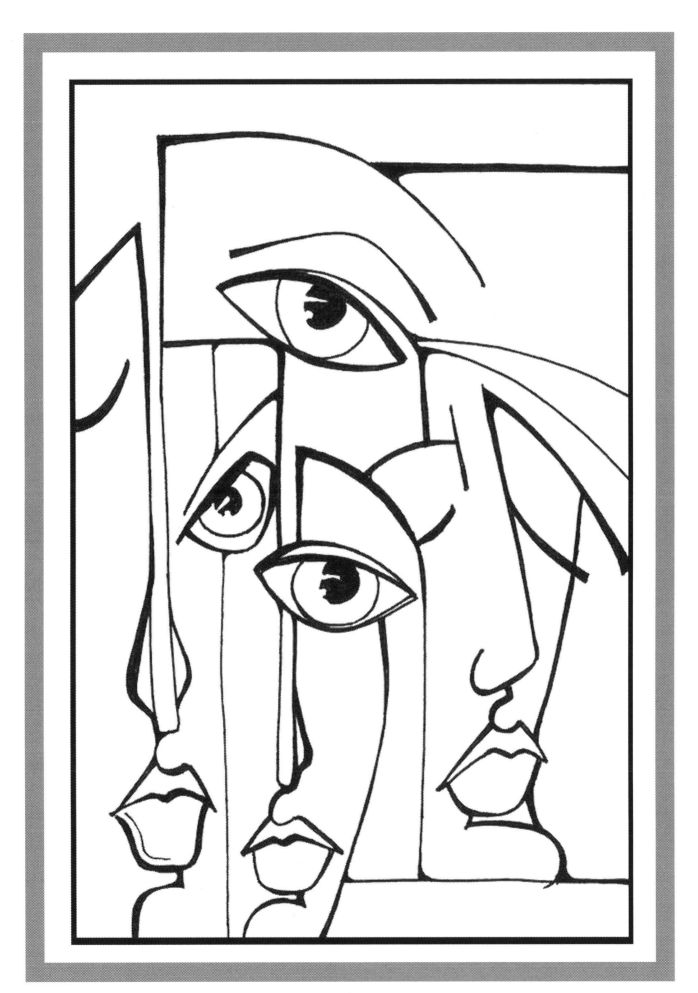

'Tilt'

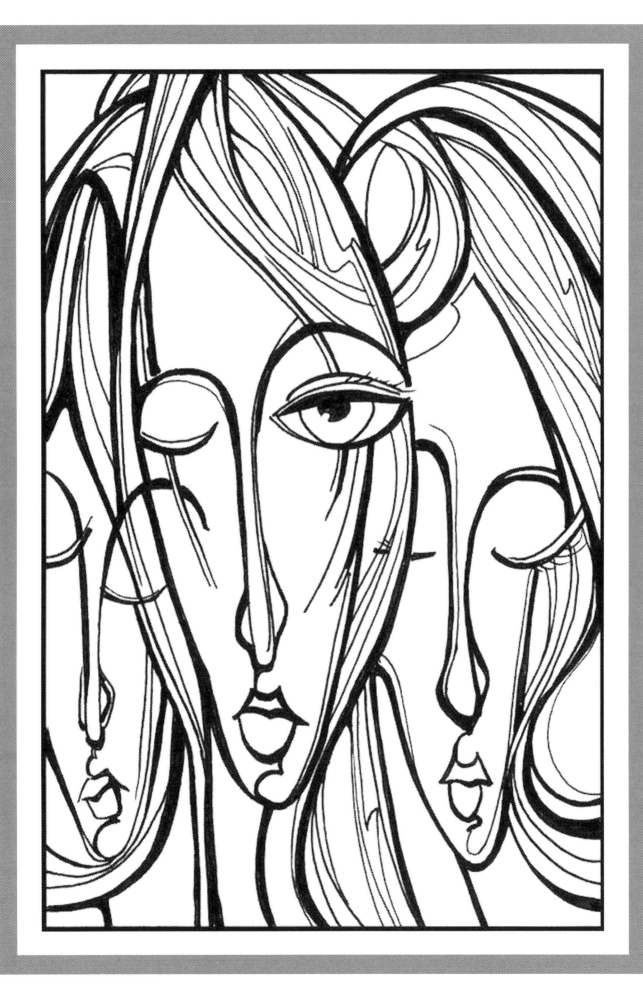

'Chil'

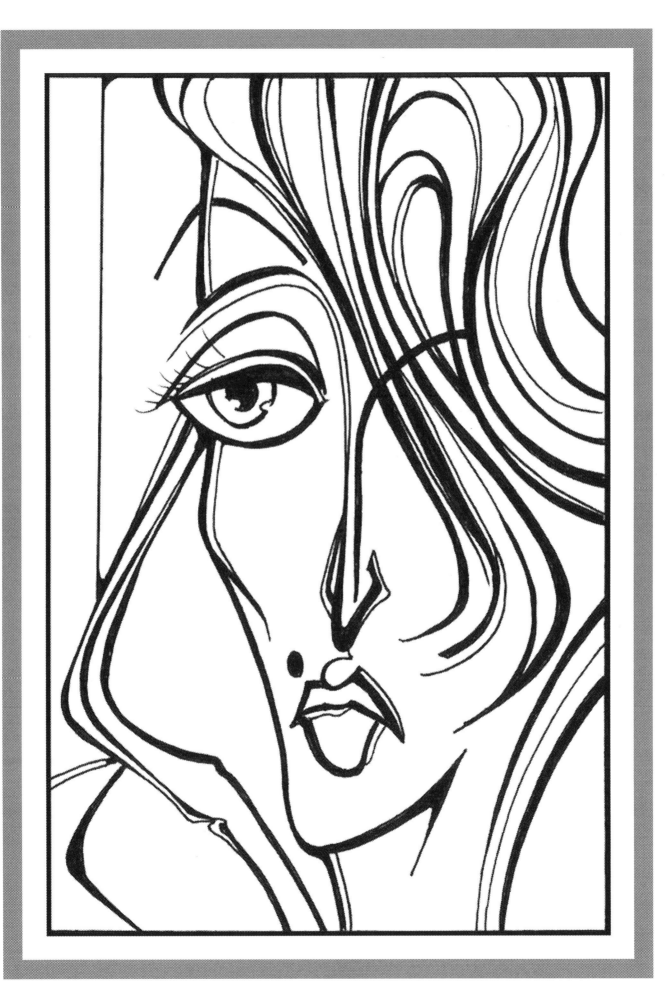

'Red'

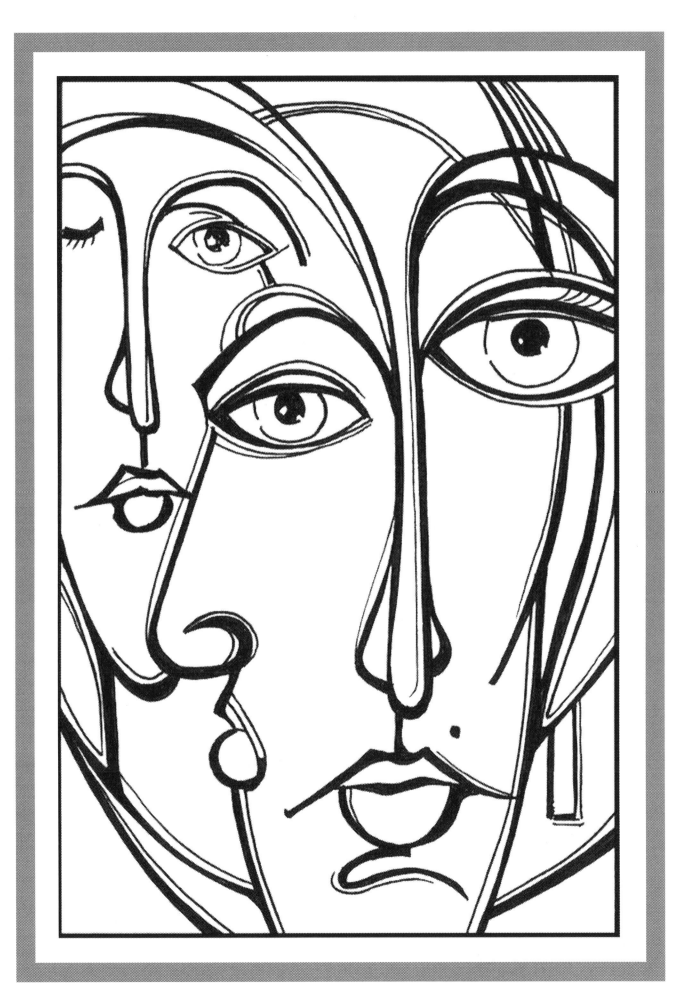

'Together 3'

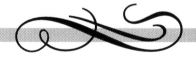

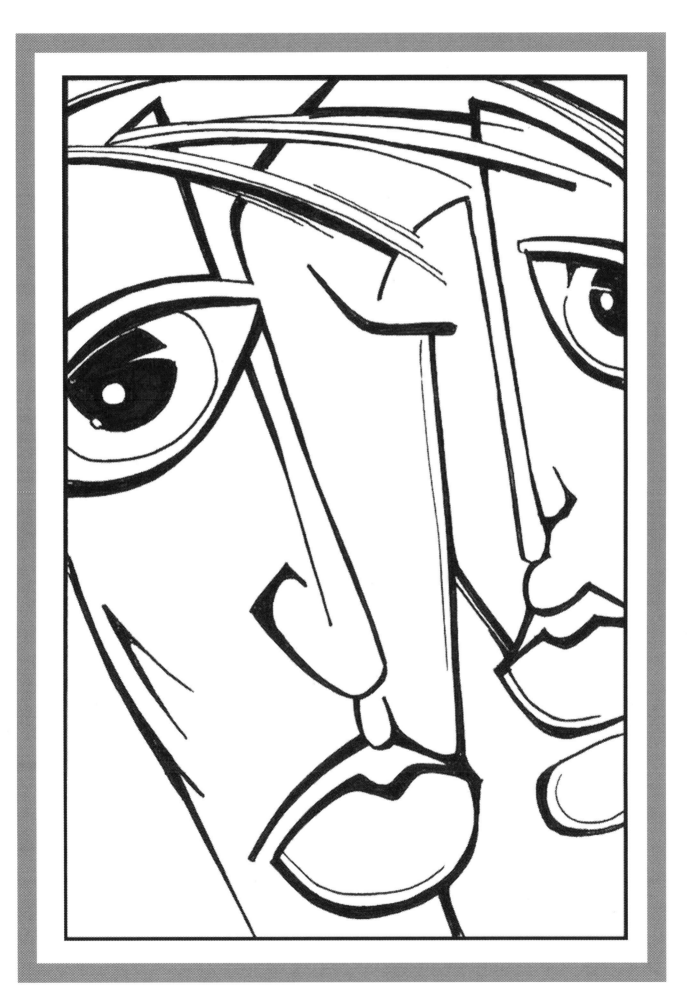

'Amicis'

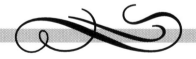

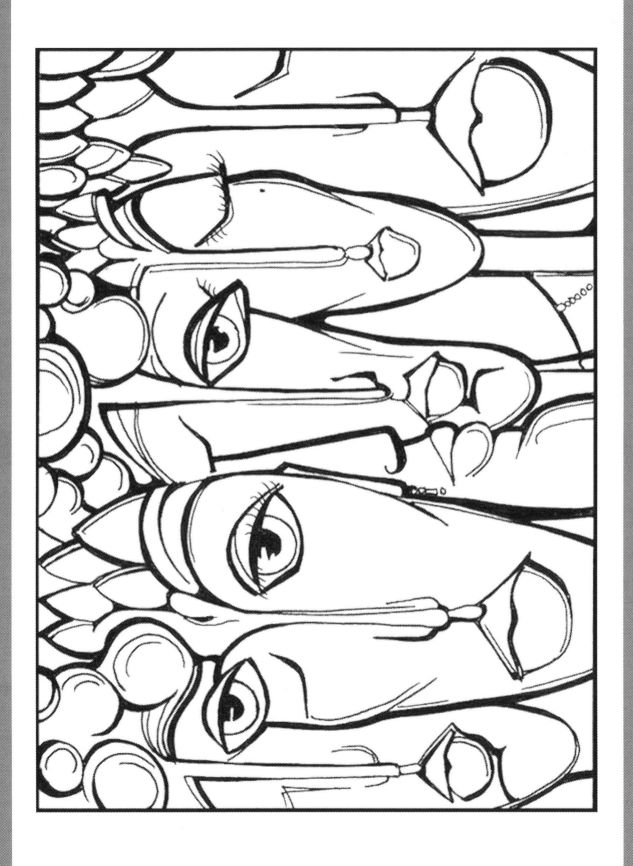

'Masks'

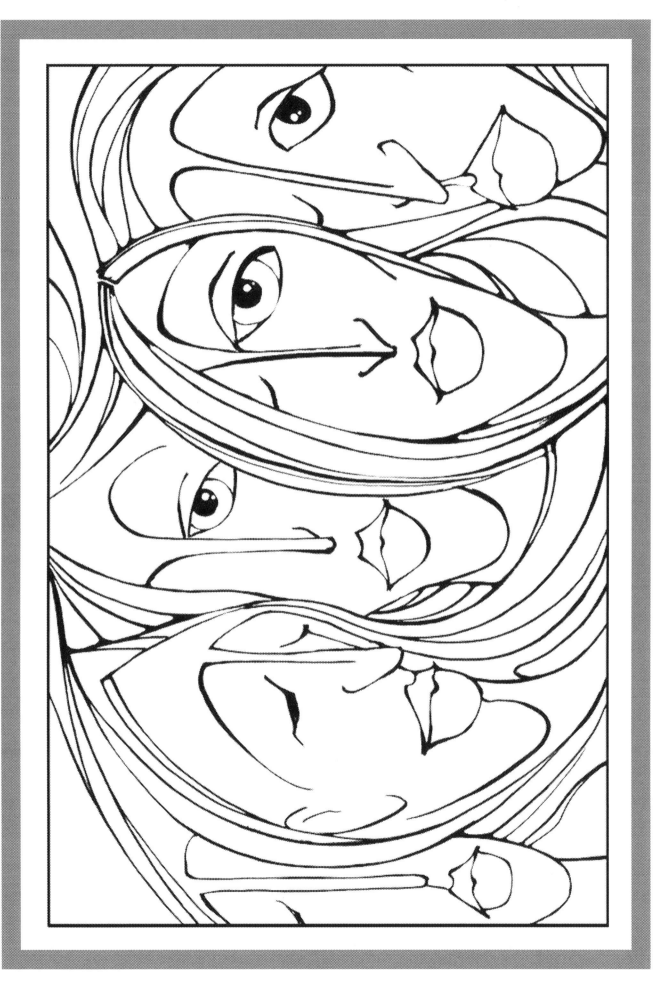

'Believers'

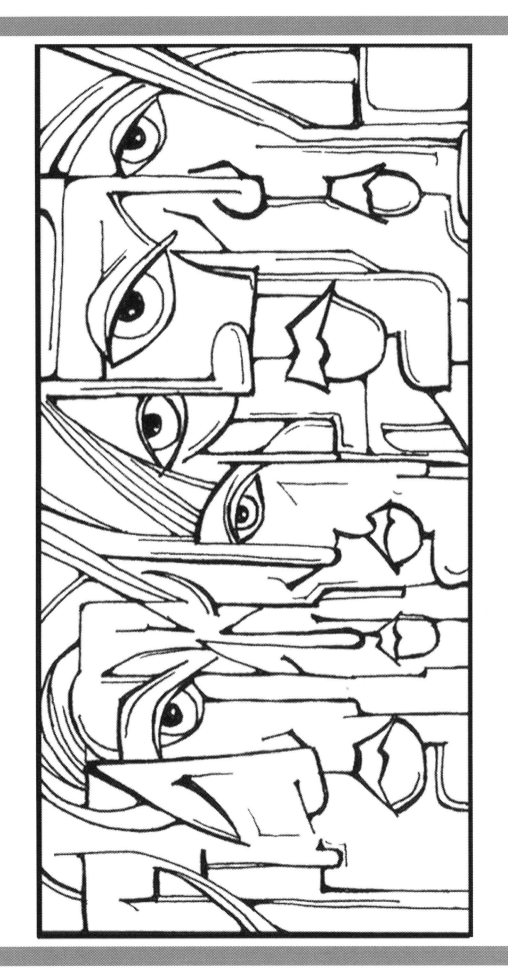

'No Choice'

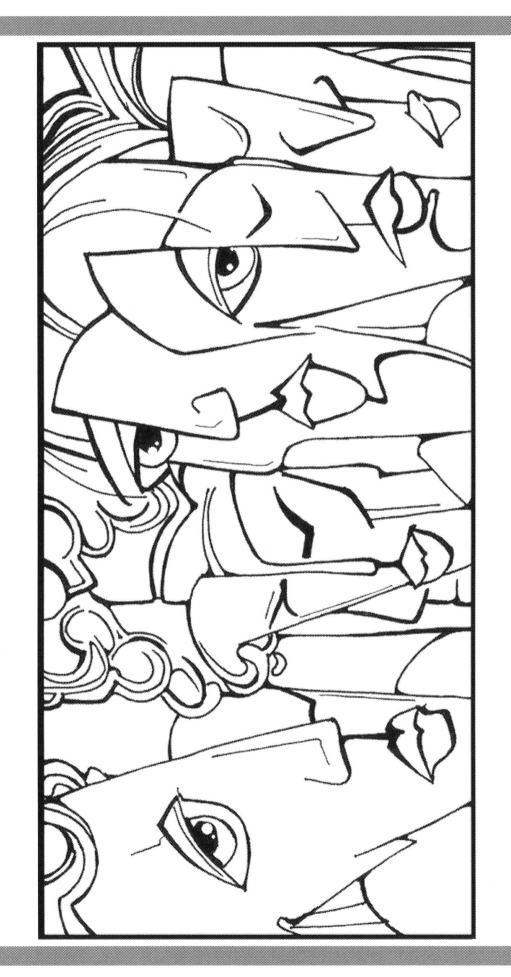

'Visions'

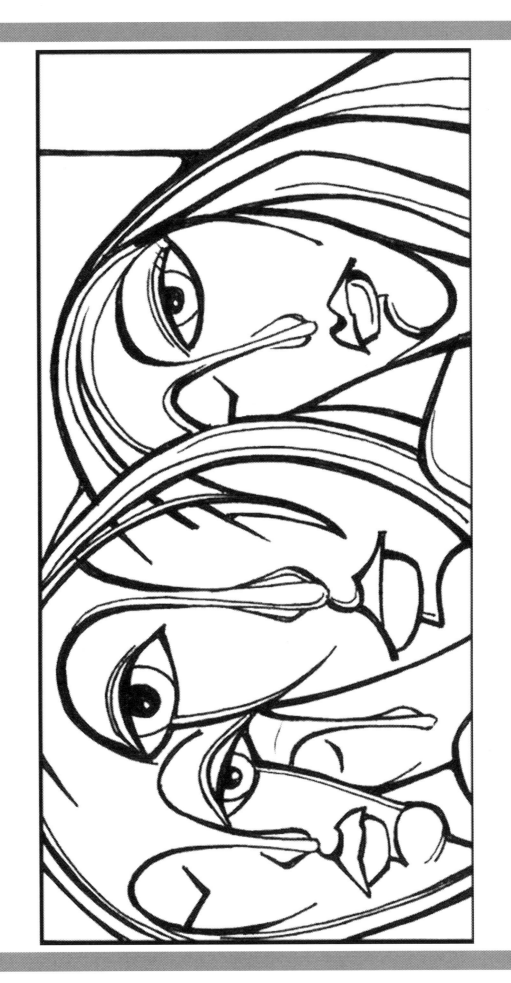

'Dreamers 2'

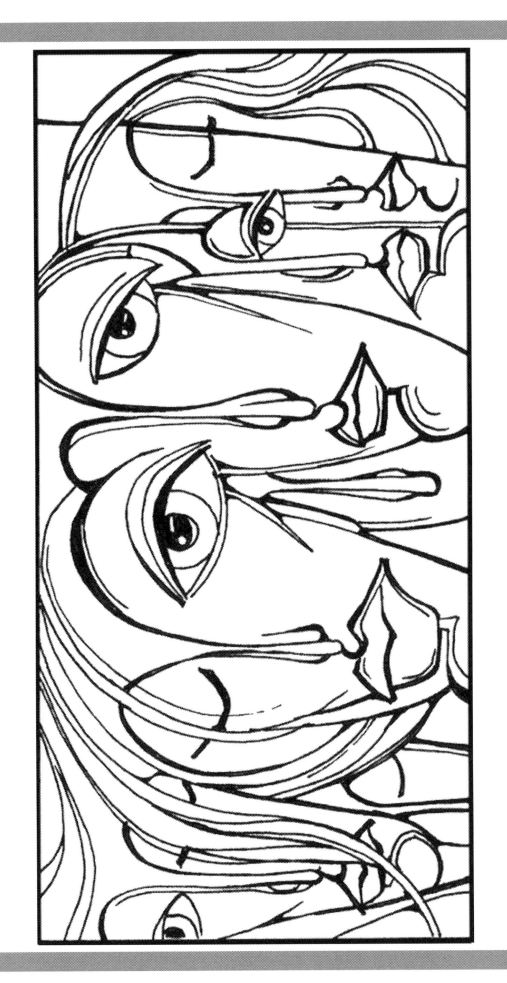

'Untitled 3'

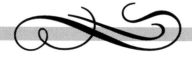

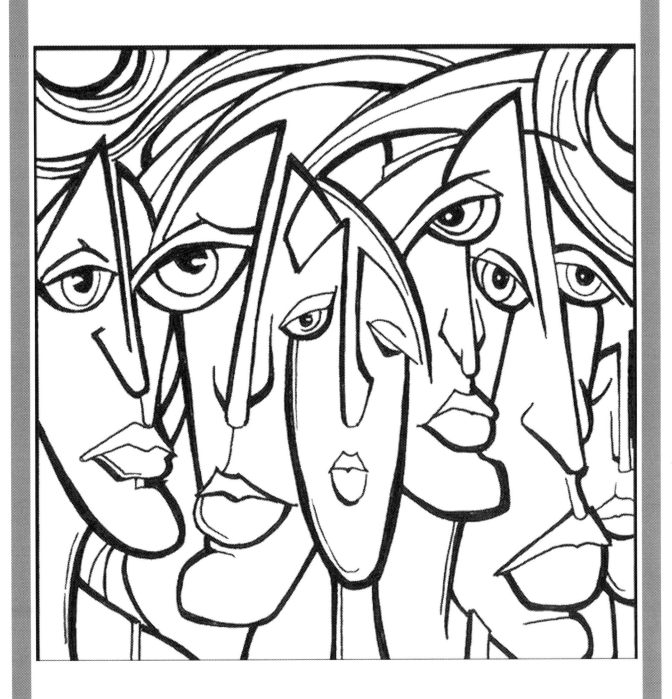

'Full Tilt'

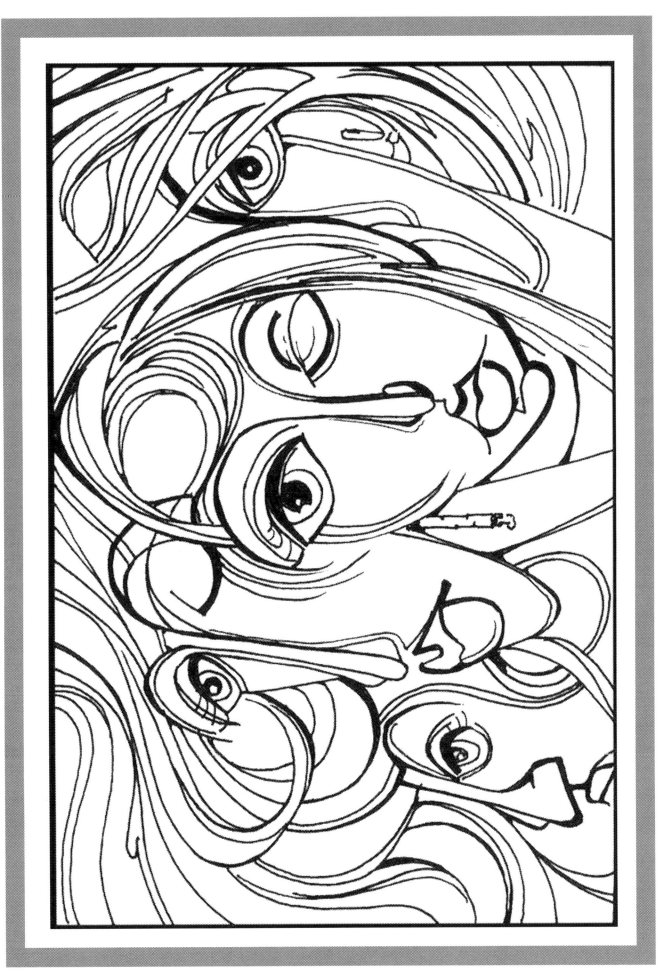

'Blush'

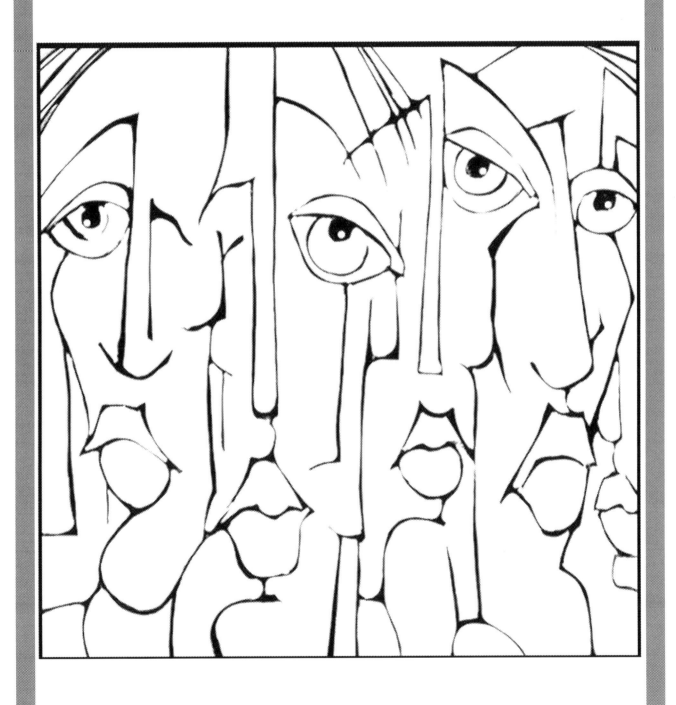

Printed in the United States
By Bookmasters